portfolio collection **Susie Brandt**

Graphics by Hector Peebles with MK
Proofreader: Katherine James
Series Editor: Matthew Koumis
Reprographics by Ermanno Beverari
Printed in Bolzano, Italy by
La Commerciale Borgogno

ISBN 1 902015 67 3

Names of Photographers
Dan Myers
Tom Grow
Joseph Levy
Jack Ramsdale
Greg Benson
Susie Brandt
Lewis Tobey
Patty Wallace
Lauren Tent
Kristine Woods

Artist's Acknowledgments
It is a pleasure to thank Sid Sachs
and Julie Courtney for their
thoughtful words; and to extend
sincere appreciation to Betsy
Brandt, Mary Brandt, Richard
Carey, Margo Mensing, Darrel
Morris, and Kristine Woods for
many editorial insights. Thanks
also to Maryland Institute College
of Art Faculty Development Fund
and the Albany Institute of History
and Art.

None of this would have been
possible without my inspiring
family, rousing teachers, and
devoted friends.

Publisher's Acknowledgments
Thanks to Margo Mensing for
introducing me to the Artist.
Thanks also to Katharina Riegler,
Jemma Jones, Hector Peebles;
Susan Lordi Marker and Dennis
Marker; Christopher Springham
of Luther Pendragon; and Paul
Richardson of The School of
Publishing, Oxford Brookes
University.

Front cover illustration:
Barb
1993-2000
barbie clothes, fabric, stuffing,
hand stitched
65 x 84in (165 x 213cm)
Collection of Peggy Greenawalt

Back cover illustration:
Water Tower Project
in collaboration with Betsy Brandt
and Richard Carey
1997
computer-altered photograph

Illustration pages 1 & 47:
Glint (detail)
1998-2001
plywood, paint, mirrors, hardware
Installation at Merion Station, PA

portfolio collection
Susie Brandt

TELOS

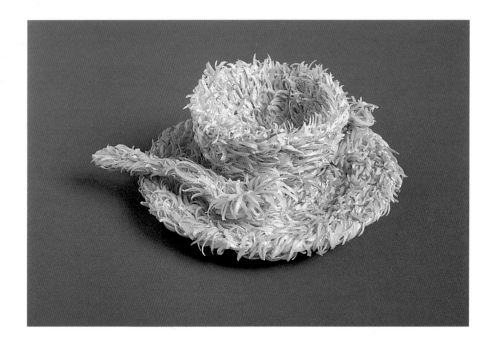

After Oppenheim
2000
nail clippings, caulk, miniature teacup
5³⁄₈ x 4½ x 2¼in (13.5 x 11.5 x 5.5cm)
Collection Robert Pfannebecker

Contents

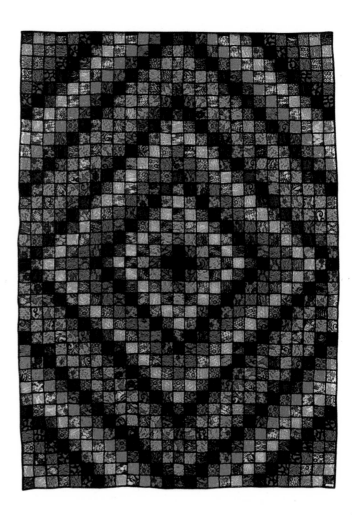

Sunshine and Shadow
(from the 'Peek a Boo' series)
1996
cheap lace, satin, machine stitched
96 x 72in (244 x 183cm)

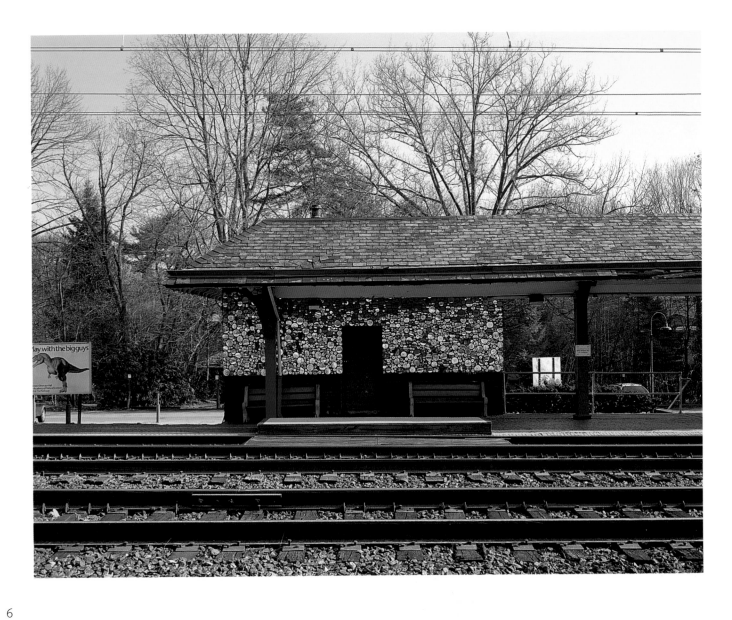

Foreword

Julie Courtney

Using the most unlikely materials, Susie Brandt tweaks our expectations, prods our perceptions, and makes works of art that are gorgeous, witty, and even hilarious. Susie transforms her medium to create confounding pieces that demand a closer look. A great collector of textiles of all sorts, from pantyhose to cheap lace to old hankies, she alters the original material to create masterpieces from art history: the cheap lace becomes stained-glass-like when hung on church walls; the varying flesh tones of panty-hose are woven pot-holder style, to recreate the intricate patterns of Anni Albers. Her work is obsessive and labor intensive, yet humor offsets the mind-spinning technique. The work is fascinating – one never tires of examining the details and wondering how on earth she managed to collect all those doilies (or hankies or Barbie clothes or clothing labels or American flags, etc). I have followed her work since her graduation from Philadelphia College of Art, now The University of the Arts. The first piece I ever saw was a hankie made of pearl buttons and telephone wire. I was smitten. It was so pretty and so un-utilitarian, break-ing the rules set by the crafts world. I loved her ironic touch.

When Susie came back to Philadelphia to replace her instructor from The University of the Arts and head the department, I wanted to be the first to show her. Although she had never done an outdoor public art project, I knew she was up to it. I invited her to make a project for a commuter train station, a charming Tudor-style building in suburban Philadelphia. She convinced the staid community to allow her to make a work that referred to the venerable Barnes Foundation, right in their neighborhood, and created *Glint*, a most extraordinary and surprising project in which she covered a build-ing with mirrored disks that reflected its environs. The various sized disks referenced the pointillism of the Impressionist masterpieces at the Barnes. In addition to mirroring the whizzing-by trains, the disks reflected the changing woods from the linear gray and brown lines of winter to the pale green of spring to the fiery colors of fall, all the while fluttering in the breeze. The piece was up for three years and evoked a sense of curiosity and wonder to all the commuters and the neigh-bors who use the park recreation-ally. When the project, *Points of Departure: Art on the Line*, was over, this was the piece most missed, and is still missed today.

Susie Brandt is a wonder. I can't wait to see what she does next.

Julie Courtney
Independent curator

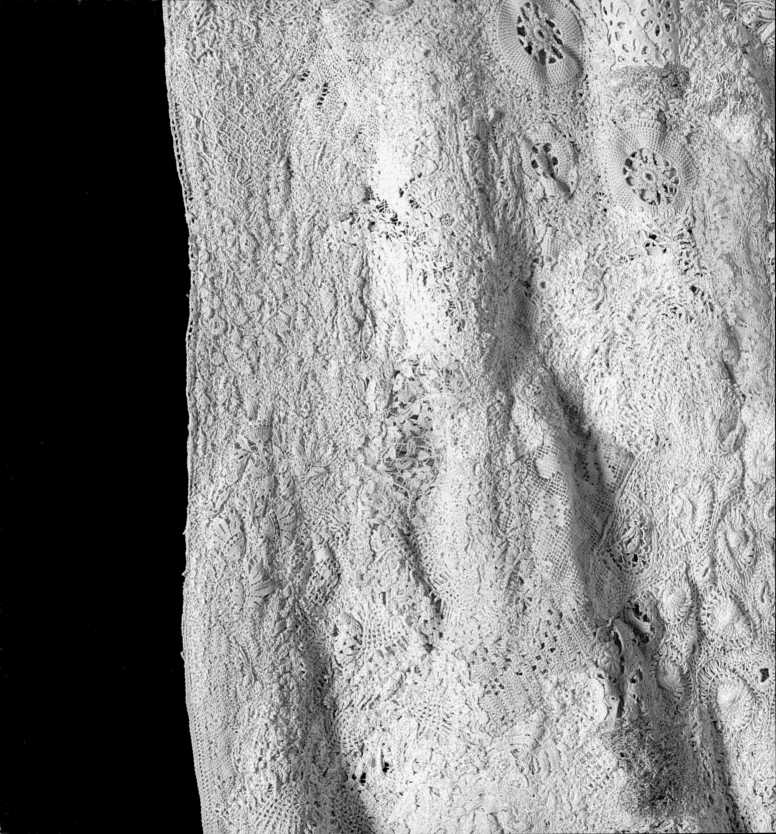

The Edge Sid Sachs

page 6:
Glint (West Side)
1998-2001
plywood, paint, mirrors, hardware
Installation at Merion Station, PA, USA

left:
Dainty (detail)
1991-1992
found doilies and lace, thread,
machine stitched
84¼ x 68½in (213.5 x 174cm)

"Whatever arena she works in, Brandt questions the appropriate through the insertion of the inappropriate" [1]
Margo Mensing

Susie Brandt is a contrary artist. Her work comes out of a compulsive need to make things and yet she often destroys in the act of generation. She does not work in a formal or traditional way; instead she uses material (and I mean this term in the broadest sense) to understand the decorative impulse of the Middle American landscape. Too beautiful, too thoughtful to be kitsch, Brandt's work nevertheless explores and makes forays into that territory. She transcends craft tradition, but not traditional craft, in making objects, environments, and fields which lull the viewer with a false sense of proper heritage only to be brought to the edge, to be engaged with new contexts and sensibilities.

Brandt comes to this naturally. Her childhood near Glens Falls, in upstate New York, was filled with people making things. Brandt's parents moved there from the mid-West to develop a ski area in 1961. They bought a small farm, then proceeded to buy up cheap contiguous parcels of mountainous land. Along with other family members they cleared trees, put up rope tows and chair lifts. Learning the business as they went along, the Brandt ski venture was critically dependent on the vagaries of tourism, weather, and the 1970s energy crisis. The fluctuating self-sufficiency of this huge, ad hoc, do-it-yourself project had a great impact on Brandt. She declares it was exhilarating and anxiety producing, a "weirdly unscripted life." Everyone in the family was encouraged to make things themselves and take pride in their inventiveness. Brandt sewed her first dress at age seven and was hooked.

Dainty
1991-1992
found doilies and lace, thread, machine stitched
84¼ x 68½in (213.5 x 174cm)

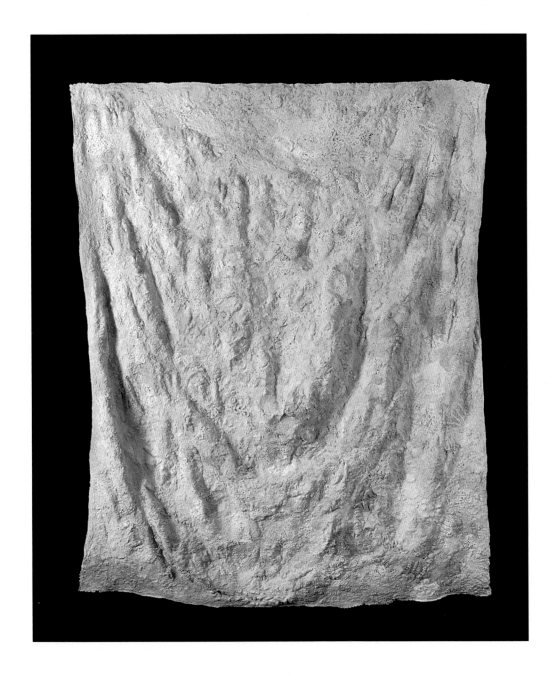

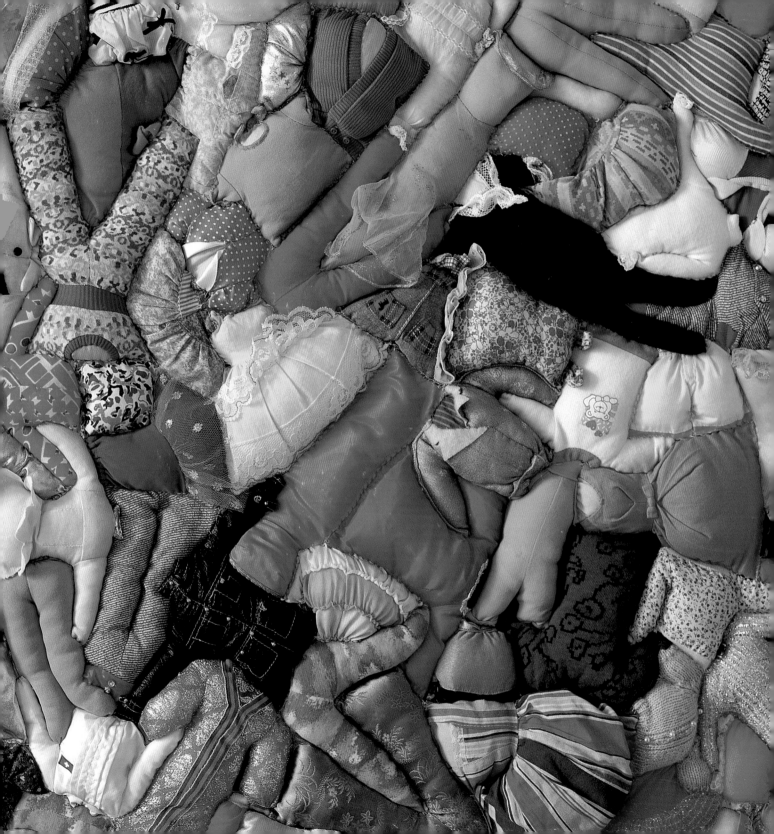

The Glens Falls region is full of mountains and trees and paper mills, chainsaw sculpture, tourist honkytonks, and rustic furniture. Some of this native culture and craft reappears transfigured in Brandt's *oeuvre*. Moreover, the feel for the landscape is a vital part of Brandt's work; she regards the textures and ripples in some of her fabrics like the topography of terrain.

She studied in Philadelphia and Chicago, two cities known for their interest in the vernacular. In Philadelphia, she studied at Philadelphia College of Art (now The University of the Arts) with Warren Seelig and Sherrie Gibson.

Barb (detail)
1993-2000
Barbie clothes, fabric, stuffing, hand stitched
65 x 84in (165 x 213cm)
Collection Peggy Greenawalt

Through Seelig, Brandt was exposed to the Jack Lenor Larson / Mildred Constantine books, *Beyond Craft* and the *Art Fabric Mainstream*, and the Lausanne International Biennial of Tapestry. Gibson was instrumental because she "taught a very eye opening textile history course." Brandt, however, rebelled against the prevailing sense of "art fabric." In the 1970s, art fabric "was pretty fascinating but I had a hard time relating to it, I think because it came out of the European Tapestry tradition, and even though I'd lived in Europe a bit, I couldn't really relate to it. I also couldn't see myself making gigantic material abstractions."

In graduate school at the Art Institute of Chicago, Brandt again studied textile history and worked with studio advisors Anne Wilson, Joan Livingstone, and Ray Yoshida. One of the most inspiring experiences was a series of field trips taken during a seminar course on collecting taught by Jim Zanzi and Helen O'Rourke.

"We visited untrained artists and their works at sites in Illinois and Wisconsin. That's when I began to understand art making as a necessary human activity." A favorite advisor was the late Christina Ramberg, then taking a break from her Imagist paintings and making purely abstract pieced quilts. Brandt and Ramberg would spend time looking through quilt books, drawing qualitative distinctions between the illustrations. "No one in Chicago made hierarchical distinctions between sewing and other forms of making."

Brandt still makes her own clothes, sews, and assembles quilts. If that sounds like generations of women and women's work, this doesn't adequately describe Brandt or her art thirty years after this position. Her clothing reconfigures fashion tropes. Let's try to describe Brandt's sense of style: too hetero to be butch, too disciplined to be punk, sporting a pork pie hat, with a shirt collaged of Hawaiian prints

or plaids clashing somewhat. She takes style and trashes it, bumps it up to another level. She looks like her work. She is funny in a serious sort of way (like Judith Schaechter, another artist with Philadelphia roots, whose work is also simultaneously functionally discursive to the craft tradition and disjunctive to it).

Brandt's first mature work involved absorbing and transcending the traditions of quiltmaking. Oddly disembodied, her quilts are the signs of what quilts mean rather than quilts simply constructed in the classic sense. That is, they manifest a dual nature; functional like true quilts, they also acknowledge a post-modern sense of historicity and coy distance from authenticity. She states, "My work seems as rooted in textile history as it is in art history – technological innovation and colonialism." The operative word there might be "seems." She is at the edge of history, post-history. When a quilt is shown on a gallery wall, an esthetic and sociological transformation takes place. It is no longer an object but a window which opens out to the (art) world. A quilt hung thus challenges and privileges the ocular-centric position of painting. But the tedious effort to make a quilt is more than a pane – it is a thing that references culture and history in ways hands-off painting cannot. For a woman, it could be loaded with a double-edged heritage both burdensome and yet continuous. You can almost hear Linda Nochlin's plaint in the background: why have there been no famous women artists? The feminist rhetoric of the late 60s gravitated to the craft tradition as a way of explaining a vast silence, a gap and maw in art history. This is not the origins of Brandt's ideas but her work, informed by the rhetoric, goes beyond it.

A quilt has warmth and memories and touch and smell. It engulfs a person experiencing it in oneiric comfort. Brandt's quilts have it both ways; they don't remove themselves from experience. They are art, but could also be used as

Some Assembly
2001-2002
Hand embroidered 'redwork' quilt showing appliances the artist has owned in her adult life
81 x 67½in (105.5 x 171cm)

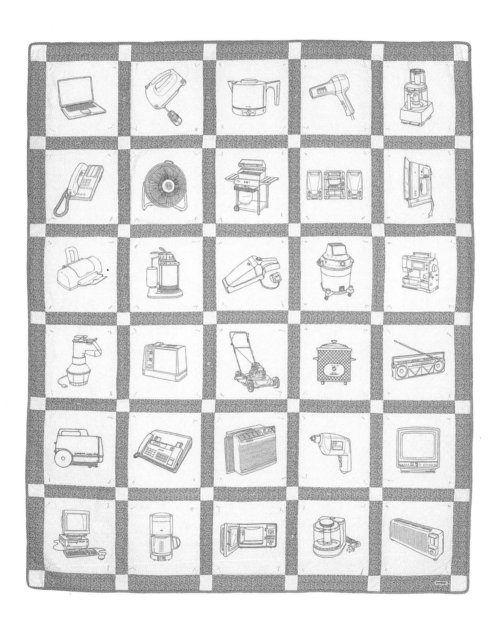

quilts, as they are sized to cover two people. Thus though they have utility and toy with functionality, they deconstruct meaning.

Of her work Brandt states: "I'd say that I'm exploring the phenomena of cloth – gathering / harvesting / processing [and] organizing systems of building (derived from weaving, netting, piecing, etc.). I've always been fascinated by the physical substance of fabric, the flexible plane, as a conductor of color, as a social document. When I make things, I'm looking to perform little alchemy. The work shouldn't be simply an accumulation of material – it must be transformed in some way. I tend to shy away from directly pictorial or narrative work, opting instead for fields that muck with the figure/ground relationship".

"Almost everything that I make comes out of a process of gathering images (*White Noise, Darned Blanket, Big Spread, Water Tower Project*), material (Barbie clothes, clothing labels, thread, lace, pantyhose), or information (everything I ate for a year, all the appliances I've owned in my adult life). I gather, and then figure how to process or organize or structure them in some way to fill a field. I realize now that is not unlike Art Fabric. What's different is my interest in the vernacular and the utilitarian. Deep down inside, I'm a formalist from the Warren Seelig / Anni Albers / Bauhaus tradition [meeting] the self-taught visionary."

Traditional needlework, quilting, embroidery, handweaving is by its very nature time consuming and repetitive. Brandt says she deals with "the horror and pleasure of a lot" trying to define and defend her obsession with obsessiveness. There is a lot of hard handwork here, a lot of recurrent making. Some works take years to find fiber components, assemble, sew, and complete. Some works are so over drawn that the initial elements are buried, disguised, camouflaged under a rich skin of threads.

There is a subversive commonality to the work that is at first not readily apparent. A quilt composed of labels evokes Ashley Bickerton's or Rosemarie Trockel's brand recognition. *Barb* (1993-2000) is a quilt comprising of appliquéd doll's clothes. This signature work took years of collecting Barbie's clothes at flea markets, yard sales, and trading to assemble. Yet note the title is not Barbie but *Barb* pointed. You reach other reference levels and you are hooked. *Ate* (1995-1997) contains a list of every meal eaten during 1995. Reading like the nightmare of a food fetishist, it comments on the way some women constantly track and are

Glint (Southeast Side) 1998-2001

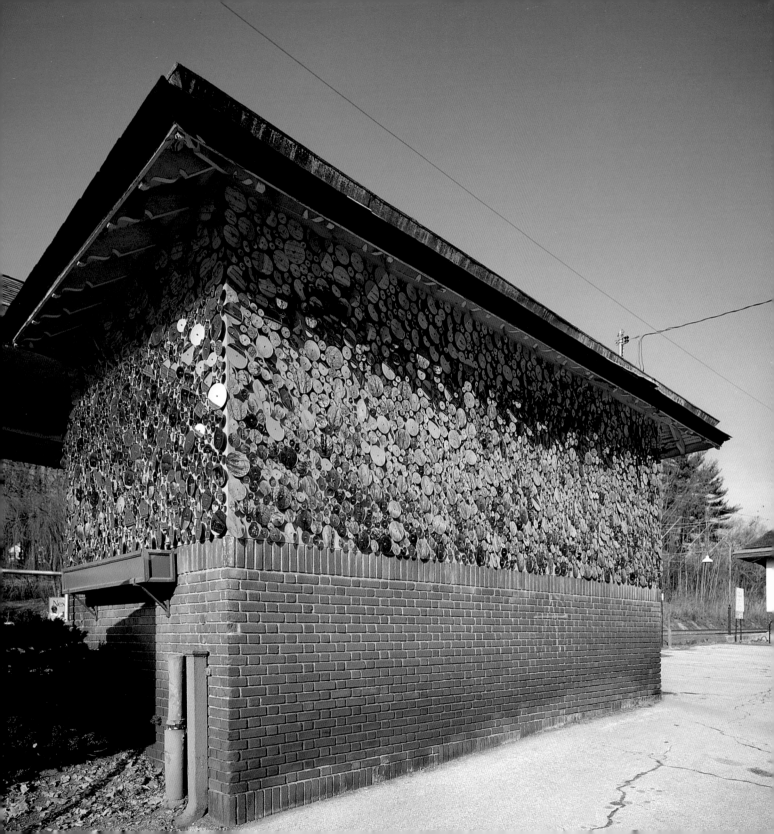

Ate (detail)
1995-1997
cloth napkins, thinsulate batting,
machine embroidered text listing
everything the artist ate in 1995
83 x 78in (211 x 198cm)
Collection Albany Institute of
History and Art

controlled by diets. Its informational quality also parallels works by conceptualists such as Hanne Darboven or On Kawara. Still it is beyond the fabrication diffidence of conceptualism; after the information was accumulated, Brandt required two more years of handwork to finish the quilt.

Some Assembly (2001-2002), visually puns the construction method of redwork quilting with the mechanical drawing of instructional plans ('some assembly required'). Autobiographic in a consumerist way, each diagram is derived from the informational pamphlets and manuals of appliances that she owned. She tweaks gender clichés – the images are masculine: a lawnmower, a barbecue, a shop vac, an air conditioner too awkwardly heavy for a woman to install – and counters these with feminine quilting.

Darned Blanket (1993-1995) was constructed over a two-year period from found embroidery scraps.

The iconographics in these fragments were not originals; they were the fabric equivalents of paint-by-number paintings. Paradoxically, by over compensating, fixing, and obliterating the imagery of these kits, Brandt revitalizes and makes the imagery both hers and everyone's, generating an original from collective facsimiles. Obsessiveness to the extreme, *Blackened Blanket* took over five years to create. Dark threads obliterate the substrate of found imagery with a density that is almost topographical in effect. If most critical commentary on Rauschenberg's erased DeKooning drawing expresses an Oedipal killing of Abstract Expressionism, Brandt's covering strikes an ambivalent Electral death to her matriarchal heritage.

The site-specific installation *Glint* (1998) was commissioned by curator Julie Courtney for a Philadelphia Exhibitions Initiative project of the Pew Charitable Trusts. The project incorporated

eight projects by different artists for commuter rail stations along the R5 rail line, which defines Philadelphia's Main Line. Situated at the Merion train station – the stop for the Barnes Foundation – *Glint* comprised thousands of acrylic mirrors screwed onto the exterior walls of the depot. Reflections dematerialized the architecture of the station. The mirrors were not fixed; they pivoted and rattled as the trains and wind moved them on their posts and in doing so further blurred the edges and boundaries of the location. In effect, the mirrors in *Glint* camouflaged the station [2]. It was truly and literally spectacular and garnered much popular and critical attention.

Even so, *Glint* was not about surface decoration. Brandt saw the mirrors as a pliable plane of fabric, which reflected a vernacular glance back at the viewer, the kind of casual vision that we only glimpse briefly from a passing train. It reminded me of Duchamp's

Dulcinea, a painting initiated by the artist's fleeting sighting of a lovely woman from a moving train. *Glint* lacks focus and that's its point. Circular mirrors, each one a little parallax off, moved in the wind, like the innumerable eyes of an insect or cross-sections of logs, a strange brew of metallic lumber, a fractured space too broken apart to be able to see one full reflection. There were other references not noted by commentators. *Glint* evoked in real time the glimmering space of Impressionist paintings. The train allowed the Impressionists access to the countryside and was frequently the subject of their paintings. And then we realized a possible reference to the Barnes Foundation, one of America's largest collections of Impressionist and Post-Impressionist works.

In Brandt's works, there is not a particular color sense or vocabulary of forms that are particular to her – given tropes are appropriated, modified, and newly configured

Ate
1995-1997
cloth napkins, thinsulate batting, machine embroidered text listing everything the artist ate in 1995
83 x 78in (211 x 198cm)
Collection Albany Institute of History and Art

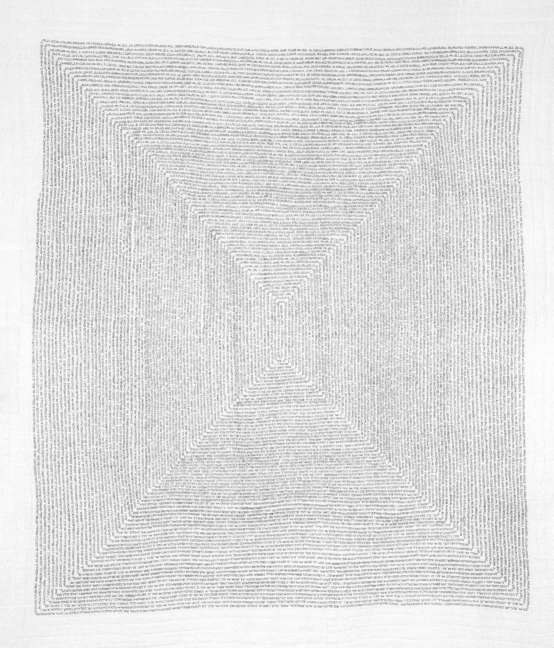

to make meaning. She doesn't invent forms; she reinvigorates and recontexturalizes them. She often revisits artworks by women such as Meret Oppenheim, or Anni Albers – heroic modernist women who utilized fibers to make images [3]. Oppenheim's canonic *Object (Luncheon in Fur)* is revisited in Brandt's version – a teacup covered in fingernail clippings. *After Oppenheim* seems newly odd or oddly new, uncanny like a Tom Friedman or Tim Hawkinson construction and not surreal. The object is both its historic reference and its material transformation. Fingernails as fiber! But then fingernails are just thicker keratinous matter than hair, which obviously is often woven. And the sexuality of Oppenheim's surrealist masterpiece isn't really that subverted as one thinks of nails scratching backs in coital ecstasy. Through co-optation, Brandt has made their visions hers.

There is perhaps not one piece that you could look at and claim to find Brandt, herself uniquely, without the forms of another, the ghosts of others, wafting into the dialog. You could look for a Koons age. Clichés are clichés because they have enough truth in them that they are overly repeated. Repeated enough and cliché becomes culture.

Perhaps in all honesty, this is the way everyone works. Anonymous was a woman. Brandt's utilization of the anonymity of Tramp art and Adirondack work, prison art, cigarette work, Victoriana, and the overblown kitsch of the overblown Niagara Falls, is a kind of homage.

Brandt and her sister Betsy [4] have collaborated nearly a dozen times since 1991. The fact that she has worked that often with her sister does not conjoin their efforts like the Starns or Chapmans but when the Brandts do work together, the results are completely assimilated. To collaborate is to lose one's self in a joint venture, no longer the authoritative heroic individual but

Blackened Blanket
1984-1989
thread, fabric, machine stitched
92½ x 76½in (235 x 194cm)
Collection Bruno LaVerdiere

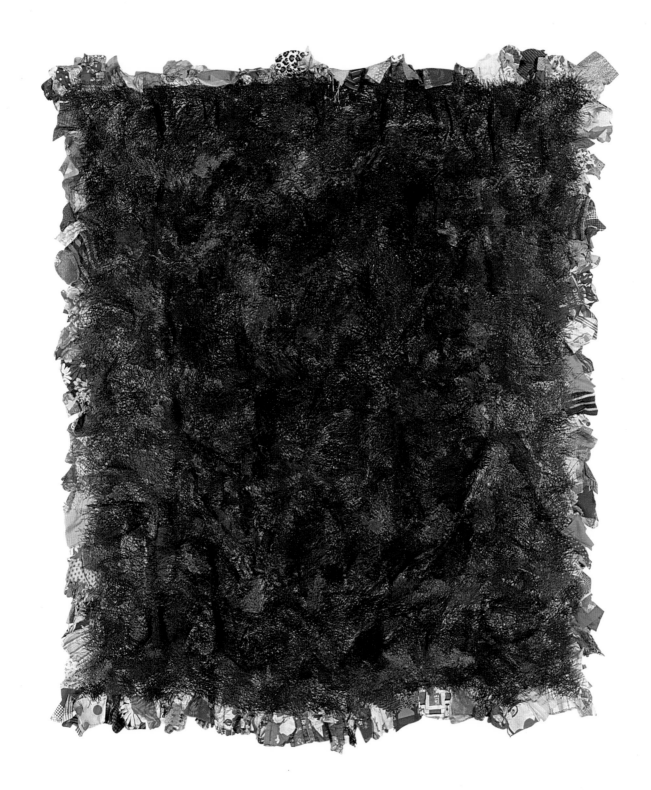

part of the negotiated team. Brandt states, "the collaborative projects are temporal and are made in response to a site or event or other circumstance. I use collaborations as a means of amending or reconfiguring my brain – it varies with the person I'm working with and how we define the situation we're confronted with."

In June of 2001, the Brandt sisters had a residency at CEPA Gallery in Buffalo, New York. They made many visits to Niagara Falls nearby to "uncover the undiscovered, to represent the under-represented, and to collect and unite [their] impressions of the surrounding landscape with one of the sublime wonders of the world." When Europeans first published accounts of Niagara Falls in 1684, the site was then virtually inaccessible. With the opening of the Erie Canal in the early 1800s, the Falls became a mecca in tune with the Romantic sublime. Uber-tourism and the pollution from chemical and hydroelectric industries in the last

century made the Love Canal an ironic coda to the paradisiacal Niagara legend.

The Brandts gathered and made a collage of historic tourist ephemera and had a faux brochure printed with the text "Yours until Niagara Falls" prominently emblazoned on it. The double-sided pamphlets were unfolded and the "wonders" side used as wallpaper for two small gallery walls. The "water" versos of the brochures were joined to create a cascading, semi-circular accumulation of fabric, an allusion to the real falls. Swag lamps (perhaps a citation of Ree Morton's *To Each Concrete Man* installation at the Whitney) with photographic water drops illuminated the space. A brown carpet covered the floor. Debris underneath the rug caused the drapery to wad up and made navigating the space unstable. "Located at the site of this domestic disruption was a vent pipe emerging from the carpet of our toxic/honeymoon/waste/fall/

dumpland of desire." The title of the installation, *White Noise*, directly references Don DeLillo's eponymous novel in which a chemical disaster causes chaos in a populace. It is a perfectly postmodern work, alluding to the Fall from the edenic wonder to the poisonous terrain of the electro-chemical wasteland today.

Brandt works on the edge where craft/crap/kitsch become literally marvelous and wondrous. There is an edge to the work, a funny cutting re-mark, whose meanings are not contained or sewn up completely. Her work deals with that slippage of meaning, the fetid fetish of the field where the inappropriate arm-wrestles with the commonplace. She takes tradition and bends it to her own ends. In doing so, Brandt does as she says: she performs a little alchemy. Her magic is tactile, raucous, visual, vernacular, and sublime.

Sid Sachs
2004

1. *Reinventing Textiles Volume 1: Tradition and Innovation*, edited by Sue Rowley, Telos Art Publishing, England, 'Textiles as Viewfinder,' essay by Margo Mensing, page 76.

2. Like the collaborative project *Water Tower* (1997).

3. Somewhere in a rigorous history of craft and art should be a reference to Elaine Sturtevant, whose appropriative work started in 1965, about two decades before such practice became widespread. Dorothy Grebenak also deserves mention: in the 1960s she made hooked rugs of Tide boxes, dollar bills, Lichtenstein paintings and recruiting posters. Grebenak's works, shown in an art context and bought by major collectors such as Vera and Albert List and John and Kimiko Powers, were perhaps marginalized by their craft ethos and are unknown today. If it were not for Dada and Pop Art, appropriation of any sort would not exist. Brandt's conversion of given formats (such as. quilts, Niagara Falls photos), or her use of historic references (as in the Anni Albers calendar), is a continuation of this lineage of appropriation.

4. Betsy Brandt has a BFA from Philadelphia College of Art (now UArts) and an MFA from the School of the Art Institute of Chicago in ceramics. Leaving pure ceramics, she has ventured into installation and works in drawing, painting, hot glue and other mixed media sculptures. Betsy and Susie Brandt have collaborated since 1991.

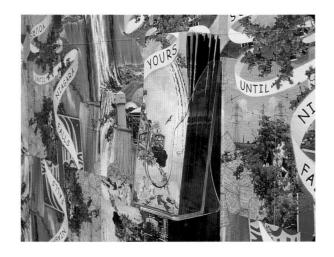

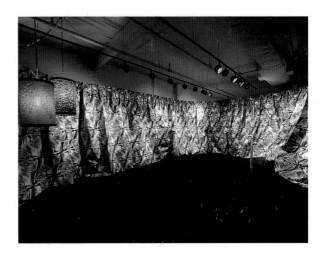

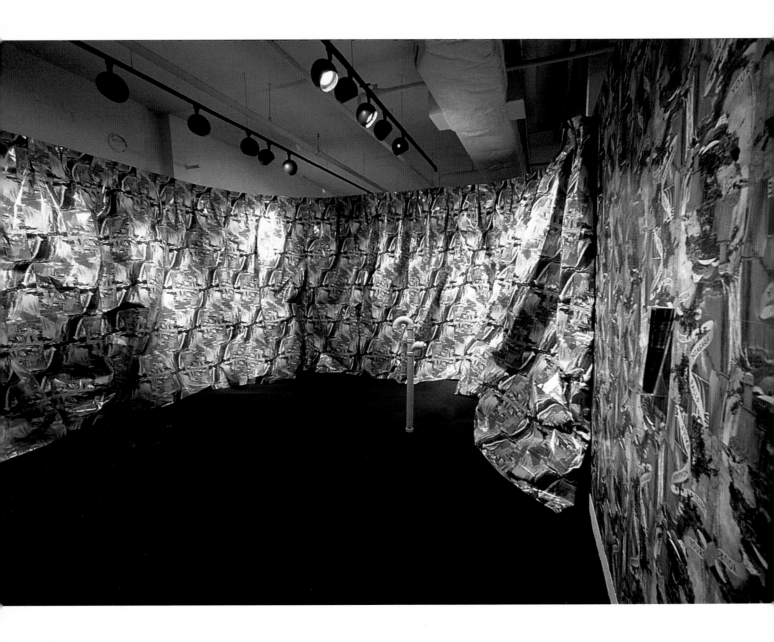

pages 25, 26 & 27:
White Noise
in collaboration with Betsy Brandt
2001
brochures. stuffed carpet, lamps,
vent pipe
Installation at CEPA Gallery,
Buffalo, NY

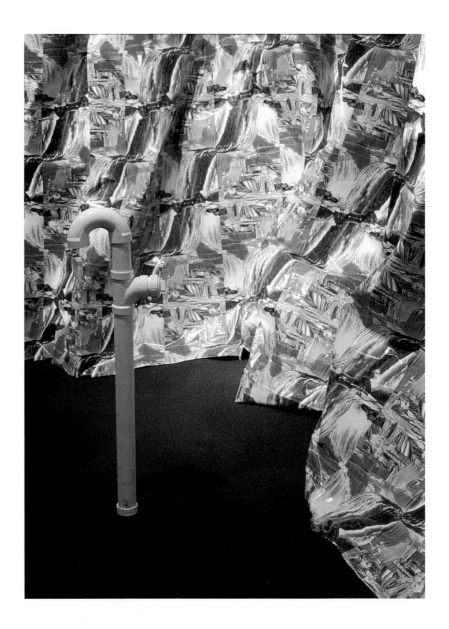

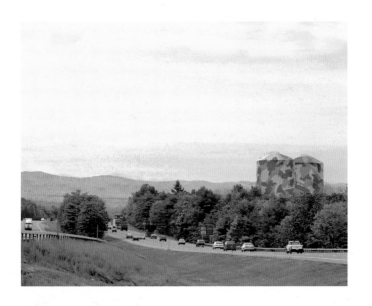 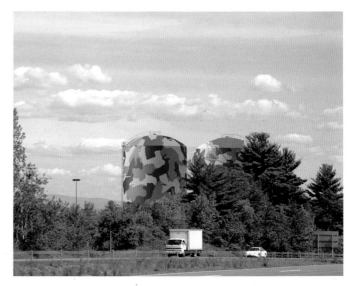

Water Tower Project
in collaboration with Betsy Brandt
and Richard Carey
1997
computer-altered photographs of
site located between exits 18 and
19 of the Adirondack Northway
(US Interstate 87), Queensbury, NY

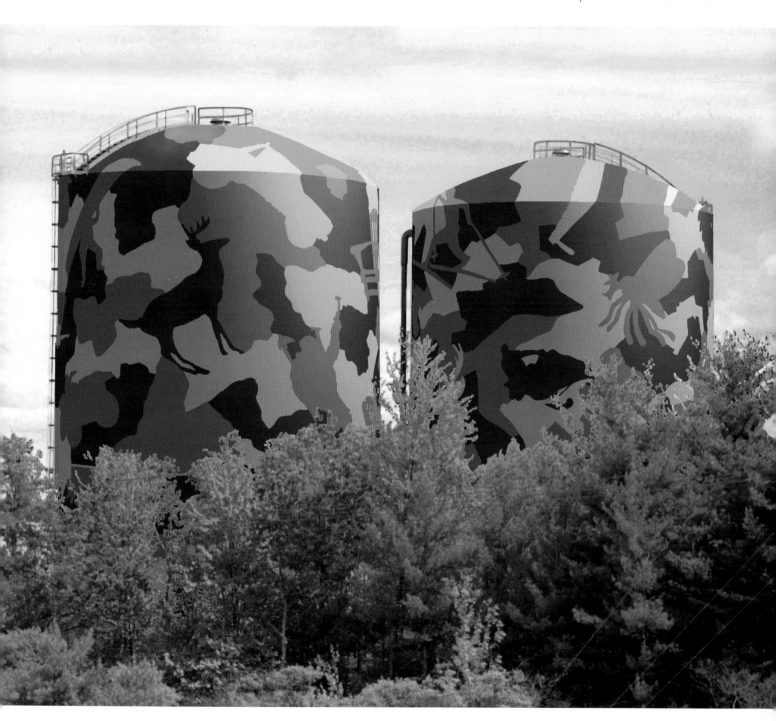

Colour Plates

page 32 & 33:
Big Spread
1987-89
print fabric, batting, thread, yarn,
machine appliqued, and hand tied
90 x 110½in (128.5 x 180.5cm)

pages 34 & 35:
After Albers
1995-1998
pantyhose, handwoven on potholder loom
(based on 1927 Anni Albers wallhanging)
72 x 58¾in (183 x 149cm)

pages 36 & 37:
O
1999
found quilt, embroidery floss, handstitched
81 x 70in (105.5 x 178cm)
Collection Steven and Jackie Garrett

pages 38 & 39:
Bud
1990-1991
fabric, thread, batting, machine stitched
86 x 73in (222.5 x 178cm)

pages 40 & 41:
Blur
1992-1996
print fabrics, thread, machine embroidered
84 x 68in (213 x 172.5cm)
Private Collection

pages 42 & 43:
Darned Blanket
1993-1995
found embroideries, thread,
machine stitched
75 x 86in (190.5 x 218.5cm)

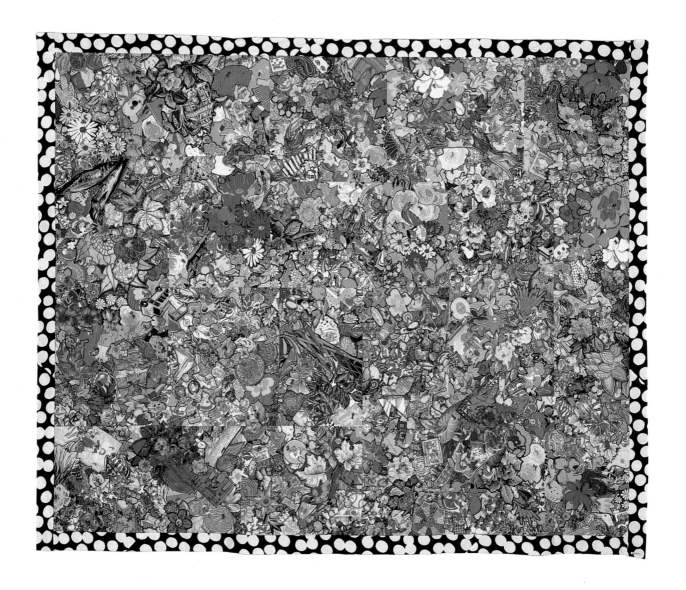

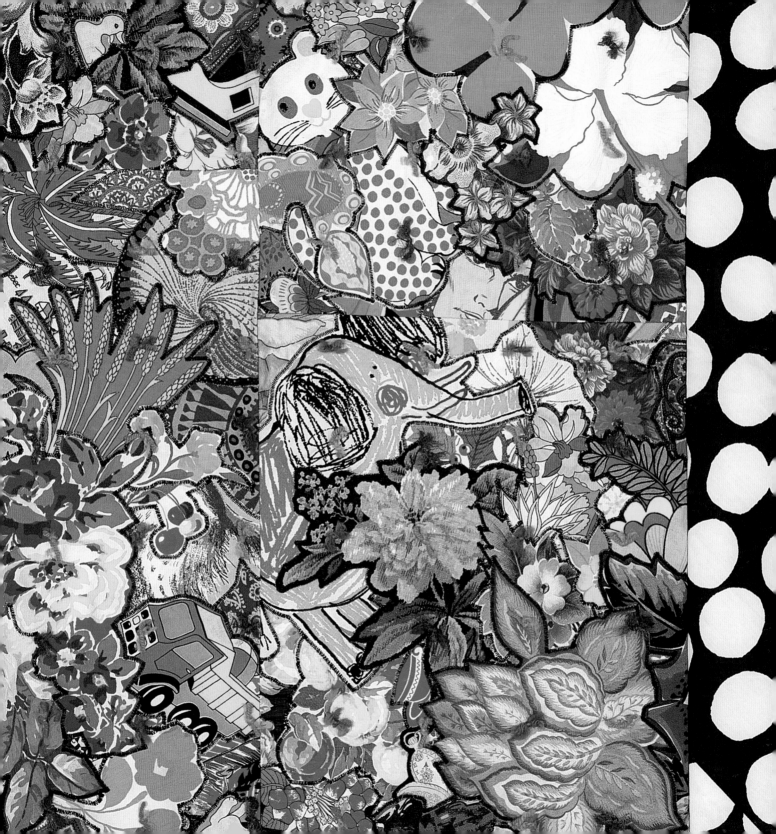

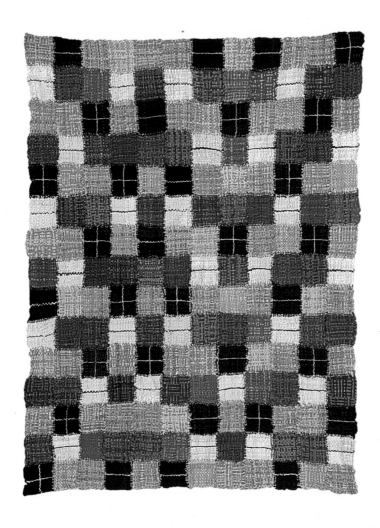

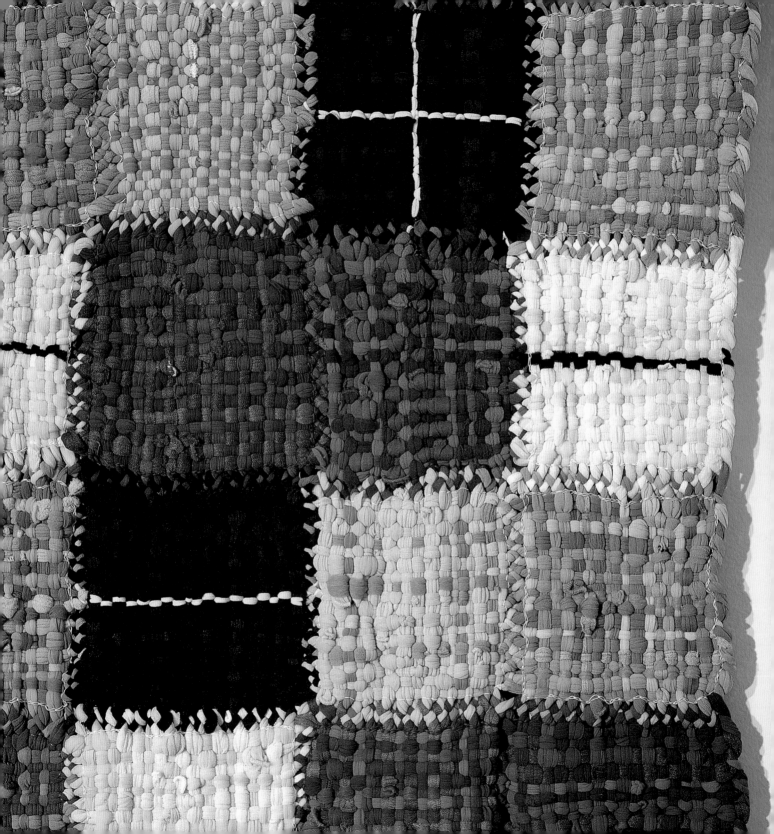

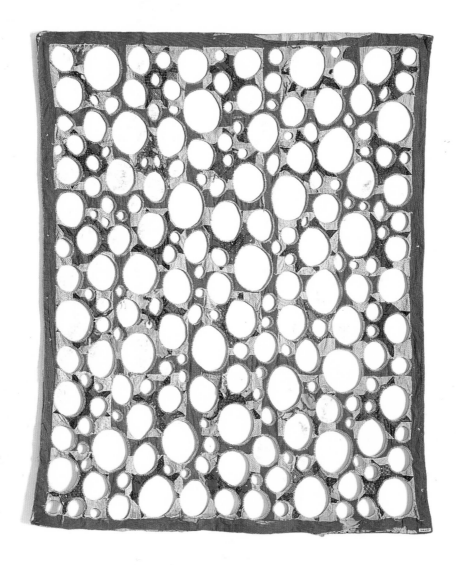

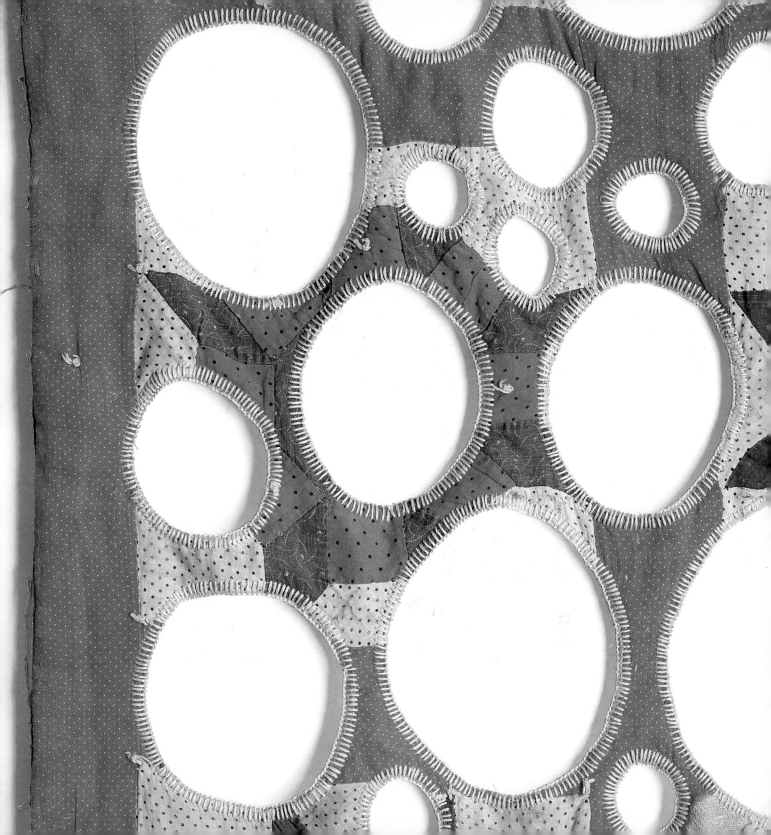

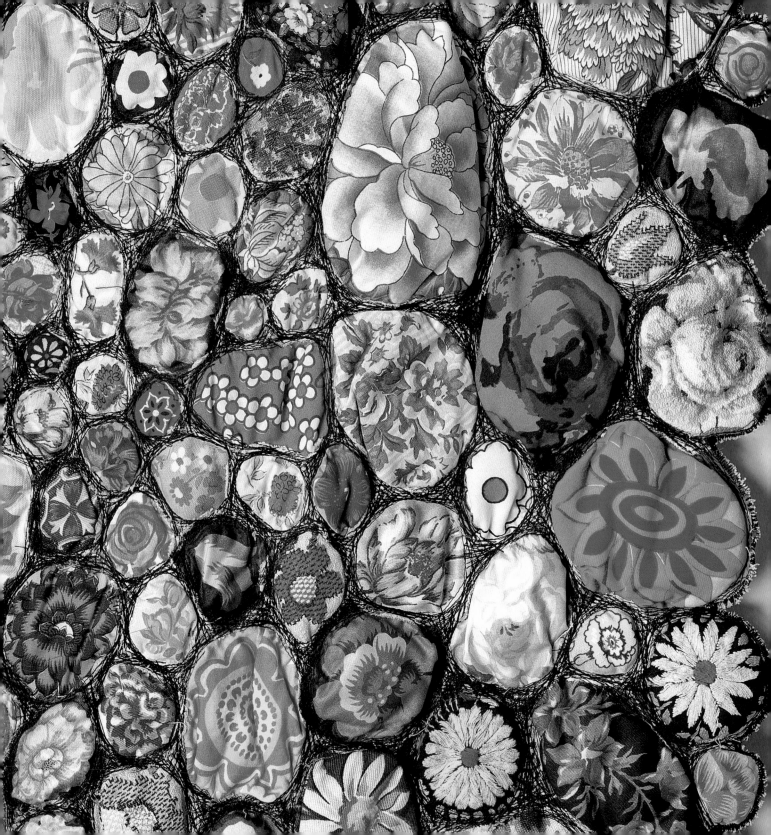

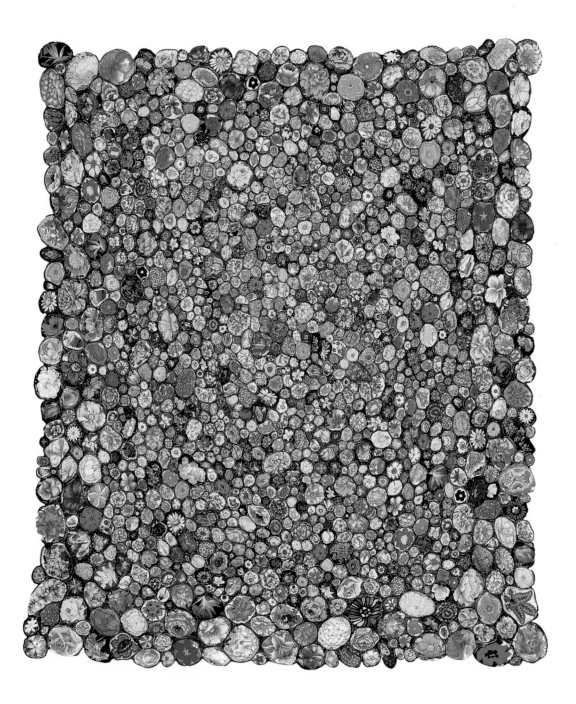

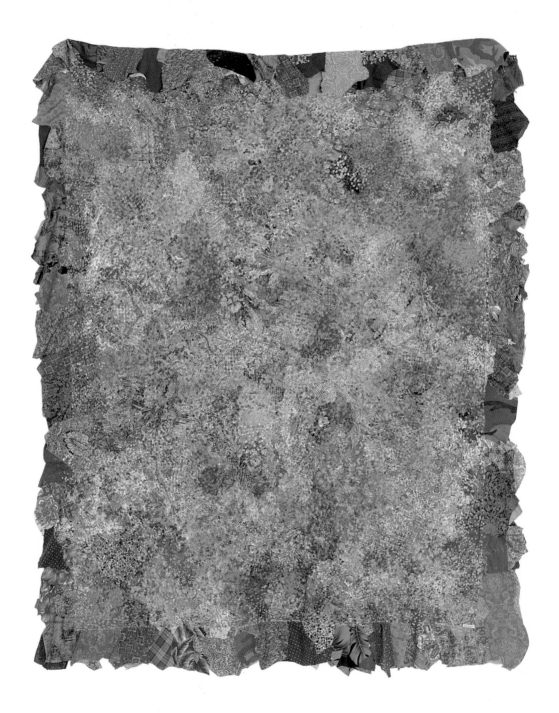

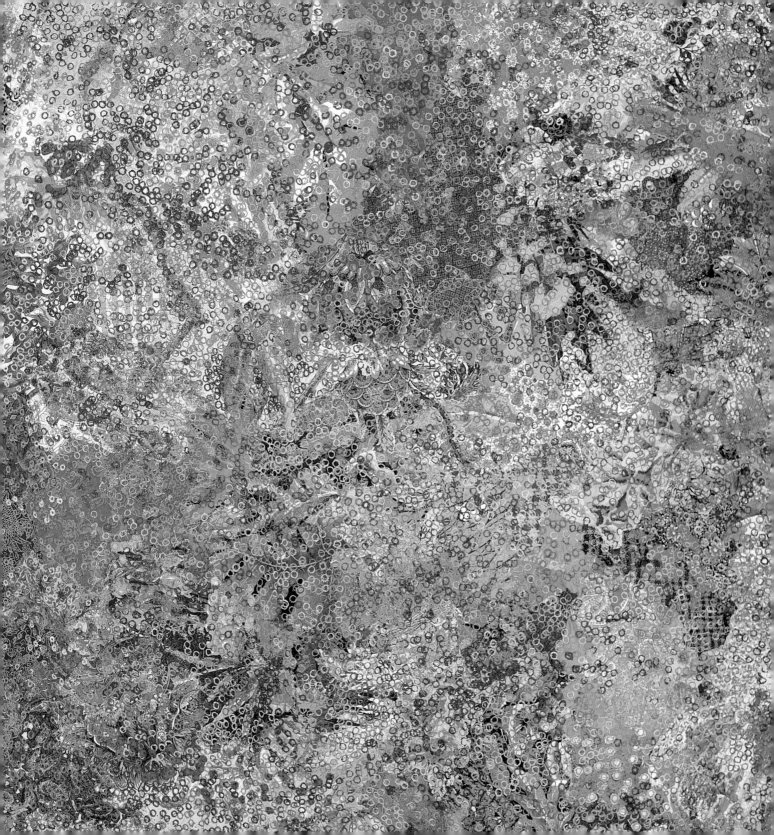

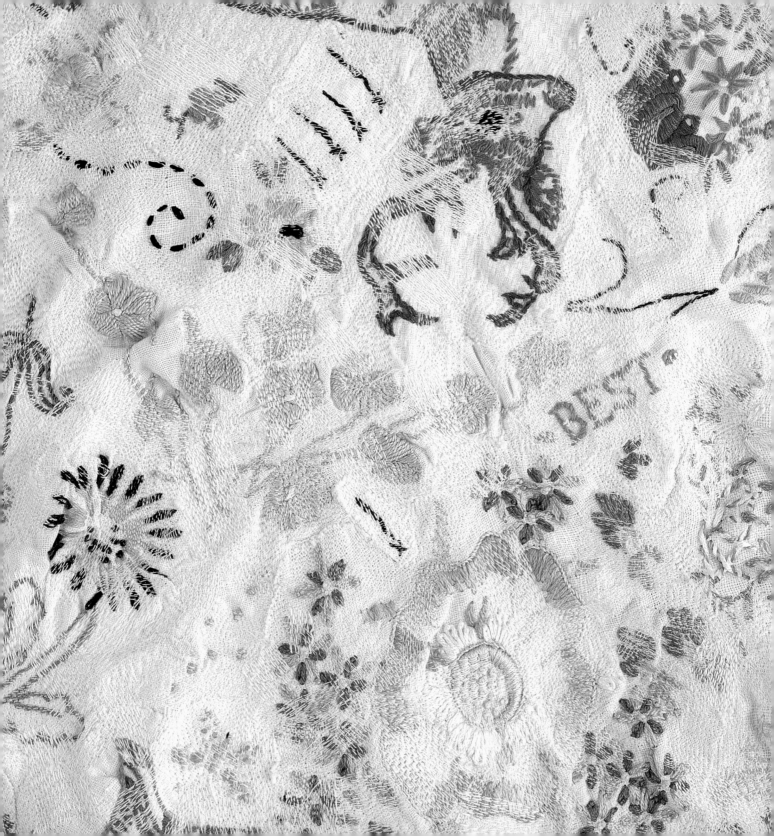

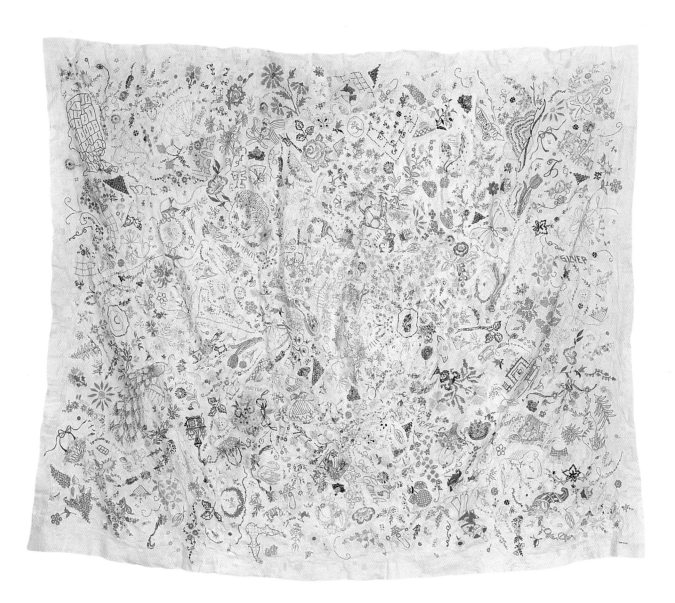

Biography

Born

1959 Muscatine, Iowa

Education and Awards

1984 BFA, Philadelphia College of Art

1987 MFA, The School of the Art Institute of Chicago, Chicago, Illinois

1993-97 New York Foundation for the Arts, Artists Fellowship

1999 The Leeway Foundation, Philadelphia, Window of Opportunity Award

2001 Mid Atlantic Arts Foundation, Artist as Catalyst Grant

Selected Solo Exhibitions

1991 *True to Life*, collab. installation with Betsy Brandt, Lake George Arts Project,
 Lake George, New York

1993 *Blankets*, Artists Space, New York, New York
 In Keeping, collaborative installation with Betsy Brandt, Laurie Wagman Gallery,
 University of the Arts, Philadelphia, Pennsylvania

1994 *Scraps and Selvage*, John Michael Kohler Arts Center, Sheboygan, Wisconsin

1995 *Adirondackland*, collab. installation with Betsy Brandt, Art in General, New York, New York

1996 *Peek a Boo*, Saint Peter's Church, New York, New York

1997 *Susie Brandt, Contemporary Quilts*, Abel Joseph Gallery, Brussels, Belgium
 Susie Brandt, Hammes Gallery, Saint Mary's College, Notre Dame, Indiana

1998 *Something from Nothing: The Conceptual Quilts of Susie Brandt*,
 Institute of Contemporary Art at Maine College of Art, Portland, Maine
 Glint, Merion Station, Pennsylvania through 2001, part of the *Points of Departure,
 Art on the Line* series of art installations in historic train stations, sponsored by
 Main Line Arts Center, Haverford, Pennsylvania

1999 *Infringe*, collaboration with Kristine Woods, Temple Gallery, Philadelphia, Pennsylvania
 Susie Brandt, Textiles, Abel Joseph Gallery, Brussels, Belgium

2001–02 *White Noise*, collab. installation with Betsy Brandt, CEPA Gallery, Buffalo, New York;
 Atlanta Contemporary Arts Center, Atlanta, Georgia

2002 *Susie Brandt*, Philadelphia International Airport, Philadelphia, Pennsylvania

2003 *Inside/Out: Re-visioning Hyde House, Susie Brandt & Margo Mensing*, Hoopes Gallery,
 The Hyde Collection, Glens Falls, New York

Selected Group Exhibitions

1990 *The Susie and Darrel Show*, Textile Arts Center, Chicago, Illinois

1991 *Grounded*, Betty Rymer Gallery, The School of the Art Institute of Chicago, Chicago, Illinois

1992 *Susie Brandt, Laurel Fredrickson, Gail Simpson*, Abel Joseph Gallery Chicago, Illinois

1993 *At Home With It*, collab. installation with Betsy Brandt, Plymouth State College, New Hampshire

1994 *Artists of the Mohawk Hudson Region Juried Exhibition*, collab. installation with Betsy Brandt, University Art Museum, State University of New York, Albany, New York

1995 *Conceptual Textiles, Material Meanings*, John Michael Kohler Arts Center, Sheboygan, Wisconsin
 Division of Labor, 'Women's Work in Contemporary Art,' The Bronx Museum of Art, New York, Museum of Contemporary Art, Los Angeles, California
 Cloth Reveries, Macalester College, Saint Paul, Minnesota

1996 *Subversive Domesticity*, Edwin A. Ulrich Museum of Art, Wichita State University, Wichita, Kansas
 Fancy, The Museum for Textiles, Toronto, Ontario, Canada
 New York State Biennial, collab. installation with Betsy Brandt, New York State Museum, Albany, NY
 Susie Brandt Textiles and Bruno LaVerdiere Drawings, Saga City Library, Saga City, Japan

1997 *Attention to Detail*, Rice Gallery, Albany Institute of History and Art, Albany, New York

1998 *Dangerous Cloth*, American Primitive Gallery, New York, New York
 New York State Biennial, New York State Museum, Albany, New York

1999 *The Comforts of Home*, Hand Workshop Art Center, Richmond, Virginia

2000 *Crosscurrents 2000; Handle With Care, Loose Threads in Fiber*, The Art Gallery, University of Maryland, College Park, Maryland
 Rue de Stassart, Galerie L n'est pas C, Brussels, Belgium
 The Day is Short, The Work is Great: Installations at the Nott, collaborative installation with Betsy Brandt, Nott Memorial, Union College, Schenectady, New York
 Miniatures, Helen Drutt Gallery, Philadelphia, Pennsylvania, Taideteollisuusmuseo (Museum of Art and Design), Helsinki, Finland
 Remnants of Memory, Asheville Museum of Art, Asheville, North Carolina

2001 *Trames d'Artistes: Les Materiels Textiles Revisitees par Six Artistes Contemporaines*, Centre Culturel de Scharbeek, Brussels, Belgium

2002 *Factory Direct*, collaborative project with Betsy Brandt and Adam Ross Cut Stone, The Arts Center of the Capital Region, Troy, New York
 Hobby Lobby, Gallery 312, Chicago, Illinois
 Labor, The Abington Arts Center, Abington, Pennsylvania

2003 *HoUSE/HoME*, Xavier Courouble Contemporary Art, collaborative installation with Betsy Brandt, Art, Washington, DC

2004 *Repeat, Repeat*, Gallery of Design, The University of Wisconsin, Madison, Wisconsin

Selected Publications and Reviews

1991 *New Art Examiner*, October, review by Olga Zdanovic

1992 *Fiberarts*, September/October, 'More Than Just a Touch, The Tactile Element in Fiber Art,' article by Polly Ullrich

1993 *Fiberarts*, Summer, 'Changing Hands Renovations in the Domestic Sphere,' article by Margo Mensing

1994 *Scraps and Selvage* (exhibition catalog), John Michael Kohler Arts Center, Sheboygan, Wisconsin, essay by Alison Ferris

1995 *Division of Labor: Women's Work in Contemporary Art* (exhibition catalog), The Bronx Museum of the Arts, Bronx, New York, essay by Lydia Yee

1996 *Surface Design Journal*, Spring 'Quilt as Construct,' article by Margo Mensing
 Cloth Reveries (exhibition catalog), Macalester College, Saint Paul, Minnesota, essay by Gerry Craig
 Fancy (exhibition catalog), The Museum for Textiles, Toronto, Ontario, Canada, essay by John Armstrong and Sarah Quinton

1997 *The Art Quilt*, by Robert Shaw, Hugh Lauter Levin Associates, Inc.

1998 *Conceptual Textiles, Material Meanings* (exhibition catalog), John Michael Kohler Arts Center, Sheboygan, Wisconsin, essay by Alison Ferris

1999 *Reinventing Textiles Volume 1: Tradition and Innovation*, edited by Sue Rowley, Telos Art Publishing, England, 'Textiles as Viewfinder,' essay by Margo Mensing

2000 *Crosscurrents 2000; Handle With Care, Loose Threads in Fiber* (exhibition catalog), The Art Gallery, University of Maryland, essays by A. Couwenberg et al
 Miniatures 2000 (catalog), Helen Drutt Gallery, Philadelphia, Pennsylvania, essay by Sigrid Wortmann Weltge
 Remnants of Memory (exhibition catalog), Asheville Art Museum, Asheville, North Carolina, essay by Ann Batchelder

2001 *Points of Departure: Art on the Line* (exhibition catalog), The Main Line Arts Center, Haverford, Pennsylvania, essay by Julie Courtney et al

2002 *Factory Direct* (exhibition catalog), The Arts Center of the Capital Region, Troy, New York, essays by Michael Oatman et al

2003 *The Washington Post*, December 10, 'It Takes a Heap o'Dust to Make House-Home,' review by Jessica Dawson
 Inside/Out Re-visioning Hyde House (community cookbook & catalog), The Hyde Collection, Glens Falls, New York, essay by Dan Cameron

Professional

1990-97	Adirondack Community College, Glens Falls, New York
1997-2002	University of the Arts, Philadelphia, Pennsylvania
2002-present	Maryland Institute College of Art, Baltimore, Maryland

Public Collections

The Albany Institute of History and Art, Albany, New York
Saga Junior College, Saga City, Saga Prefecture, Japan
The Neutrogena Collection, Museum of International Folk Art,
A Unit of the Museum of New Mexico, Santa Fe, New Mexico
Adirondack Community College, Queensbury, New York

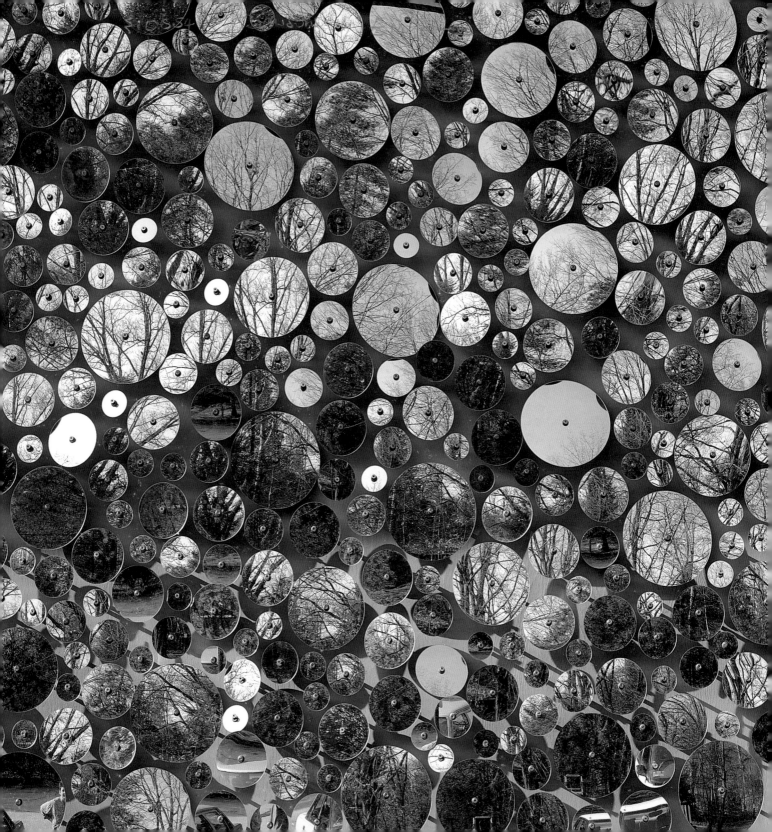